The Hebridean Birthday Book

Illustrations by Mairi Hedderwick

Corncrake
Coll .coznaigbeg

Published in 2006 by
Birlinn Limited
West Newington House
10 Newington Road
Edinburgh
EH9 1QS

www.birlinn.co.uk

ISBN10: 1 84158 460 6
ISBN13: 978 1 84158 460 7

British Library Cataloguing-in-Publication Data
A catalogue record for this book is available from the British Library

Printed and bound in China on behalf of Compass Press Ltd

Screeching Tern

These Hebridean sketches have been garnered over a period of forty years – some whilst living on one of the islands, others as I escaped from mainland exile. Some landmarks are no more – a post box disappeared, the old pier superseded by the new, many hens long gone into the pot. The mountains and headlands and the horizon line of the sea, however, never change – or diminish. And neither do the midges.

The Clyde island of Arran is not truly Hebridean, but as one set of forebears hailed from Corrie, I am sure they will be pleased at its inclusion; as I hope you are with this Hebridean Birthday Book.

— Mairi Hedderwick

1 January

2 January

3 January

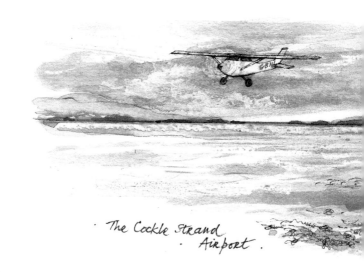

The Cockle Strand
Airport.

4 January

5 January

6 January

7 January

Bakka

8 January

9 January

10 January

11 January

12 January

13 January

14 January

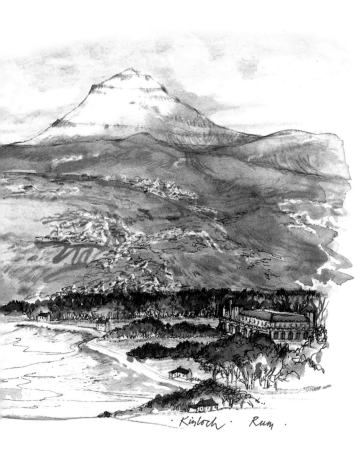

·Kinloch· ·Rum·

15 January

16 January

17 January

18 January

19 January

20 January

21 January

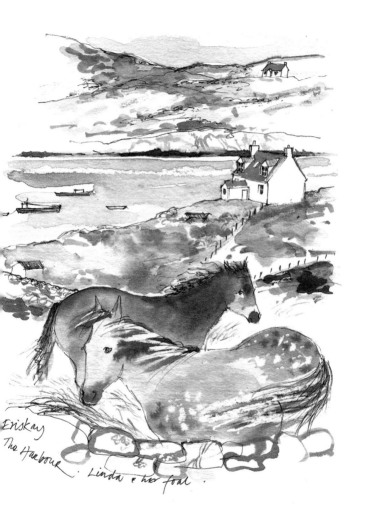

Eriskay
The Harbour . Linda & her foal .

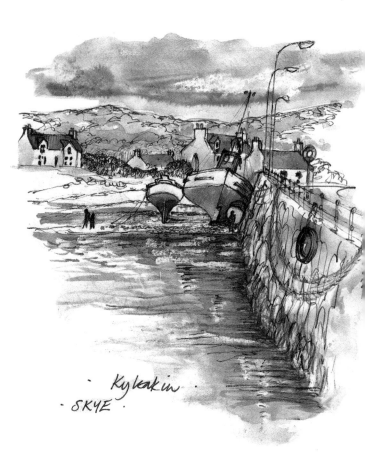

Kyleakin ·
· SKYE ·

22 January

23 January

24 January

25 January

26 January

27 January

28 January

29 January

30 January

31 January

1 February

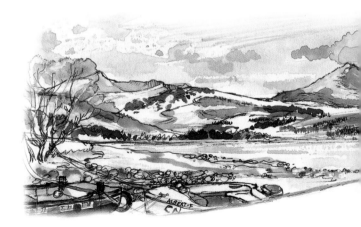

February

February

February

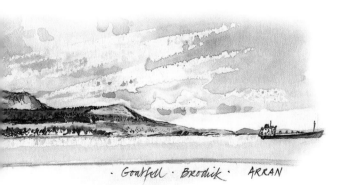

· Goatfell · Brodick · ARRAN

5 February

6 February

7 February

8 February

9 February

10 February

11 February

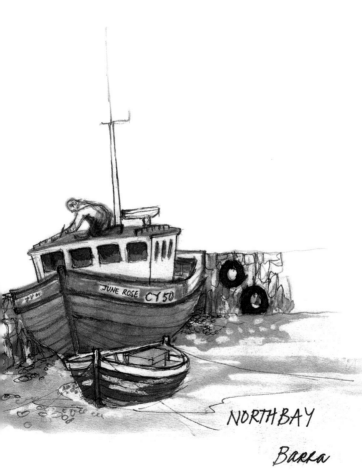

NORTHBAY

BARRA

12 February

13 February

14 February

15 February

16 February

17 February

18 February

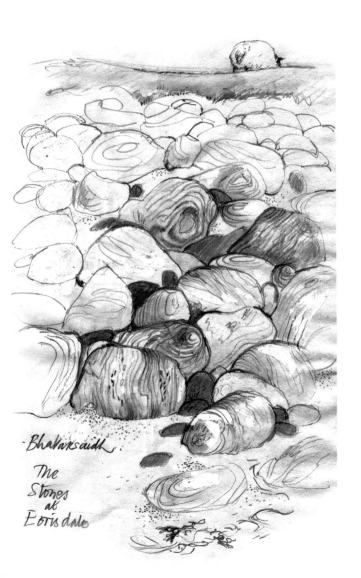

Bhalansaidh

The
Stones
at
Eorisdale

19 February

20 February

21 February

22 February

23 February

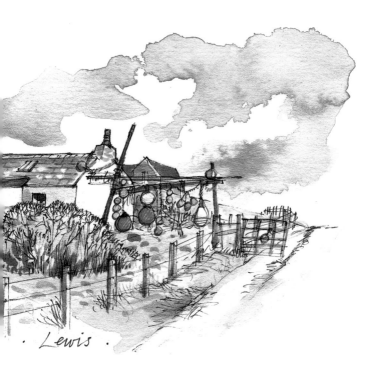

Lewis

26 February

27 February

28 February

29 February

1 March

2 March

3 March

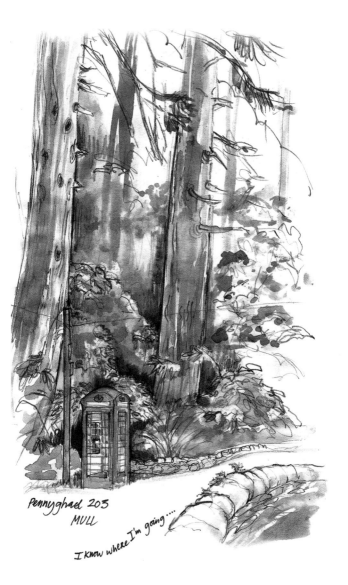

Pennyghael 203
MULL

I know where I'm going....

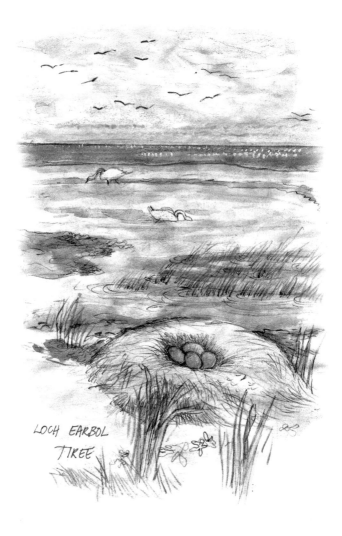

LOCH EARBOL
TIREE

4 March

5 March

6 March

7 March

8 March

9 March

10 March

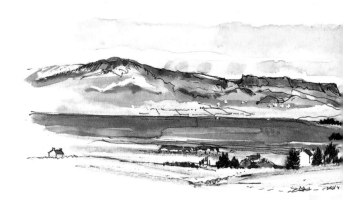

11 March

12 March

13 March

14 March

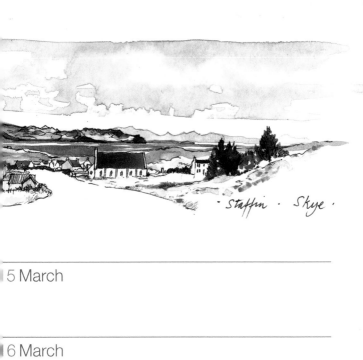

· Staffin · Skye ·

5 March

6 March

7 March

18 March

19 March

20 March

21 March

22 March

23 March

24 March

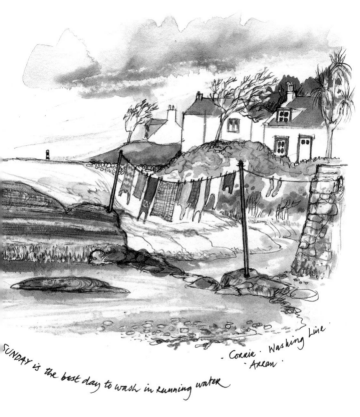

· Corrie · Washing Line
· Arran ·

SUNDAY is the best day to wash in running water

25 March

26 March

27 March

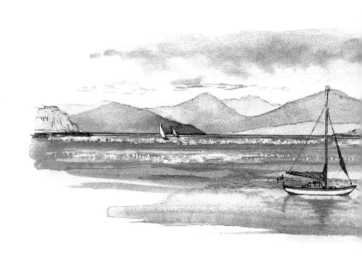

28 March

29 March

30 March

31 March

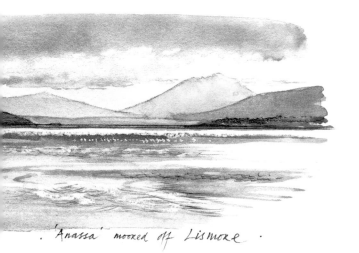

. 'Anassa' moored off Lismore .

1 April

2 April

3 April

4 April

5 April

6 April

7 April

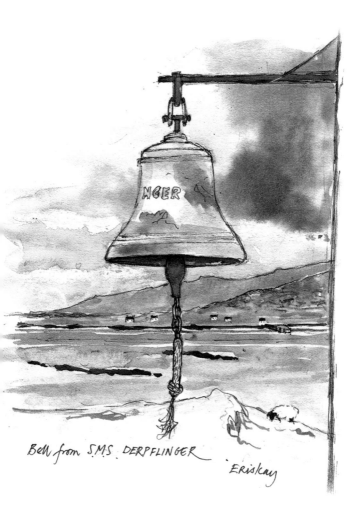

Bell from S.M.S. DERPFLINGER

Eriskay

8 April

9 April

10 April

11 April

12 April

13 April

14 April

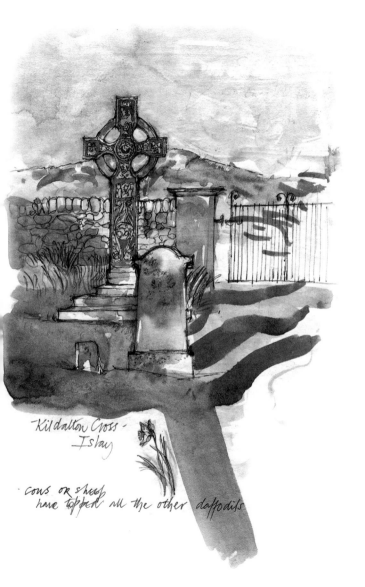

Kildalton Cross -
Islay

cows or sheep
have topped all the other daffodils

15 April

16 April

17 April

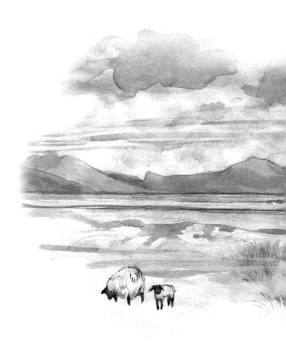

18 April

19 April

20 April

21 April

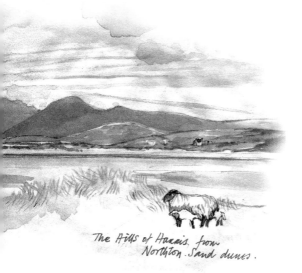

The Hills of Harris, from
Northton. Sand dunes.

22 April

23 April

24 April

25 April

26 April

27 April

28 April

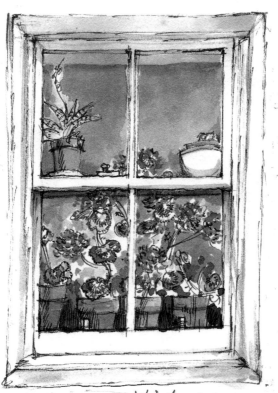

. Window . IONA .

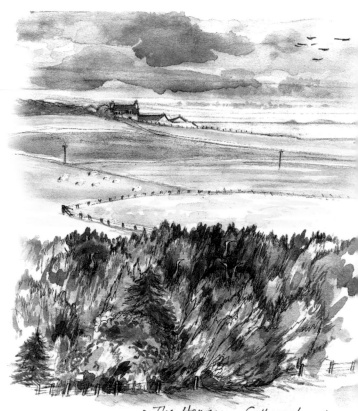

- The Heronry · Gallanach
· Coll ·

29 April

30 April

1 May

2 May

3 May

4 May

5 May

6 May

7 May

8 May

9 May

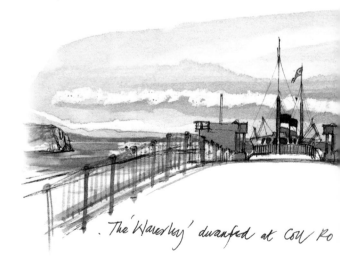

. The 'Waverley' dwarfed at Coll Ro

0 May

1 May

2 May

13 May

14 May

15 May

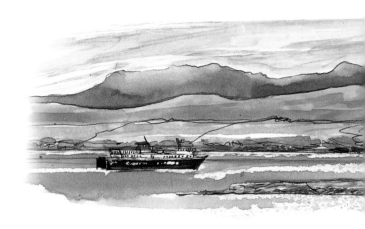

6 May

7 May

8 May

9 May

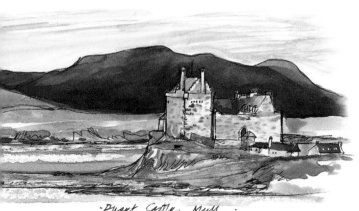

Duart Castle. Mull.

20 May

21 May

22 May

23 May

24 May

25 May

26 May

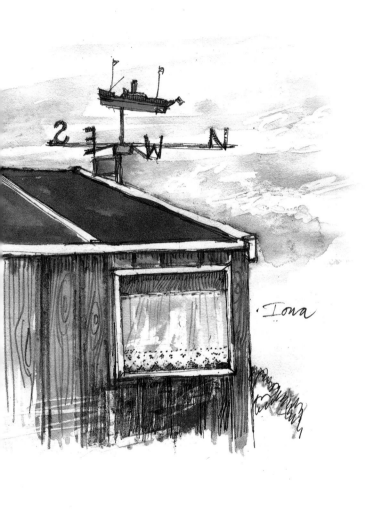

Iowa

27 May

28 May

29 May

30 May

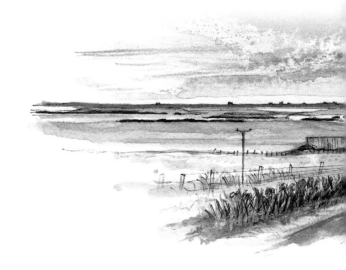

31 May

June

2 June

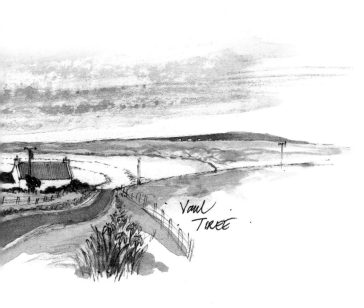

Vaul
Tiree

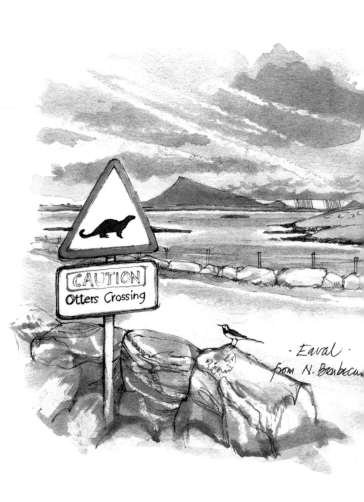

CAUTION

Otters Crossing

· Eaval ·
from N. Benbecula

June

June

June

June

June

June

June

10 June

11 June

12 June

13 June

14 June

15 June

16 June

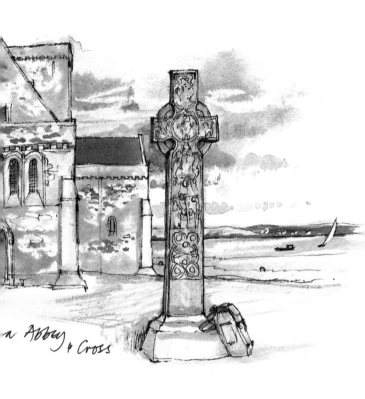

a Abbey & Cross

17 June

18 June

19 June

20 June

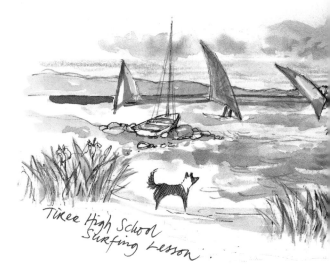

Tiree High School
Surfing Lesson.

21 June

22 June

23 June

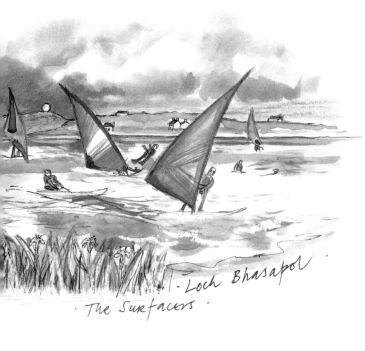

· Loch Bhasapol ·

· The Surfacers ·

24 June

25 June

26 June

27 June

28 June

29 June

30 June

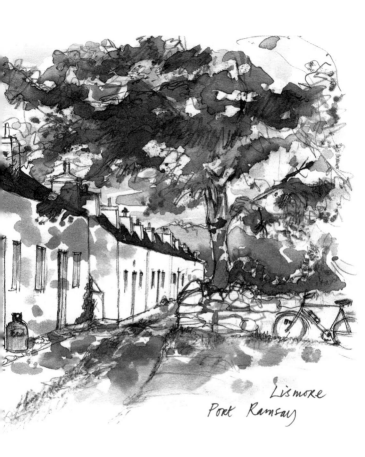

Lismore
Port Ramsay

1 July

2 July

3 July

4 July

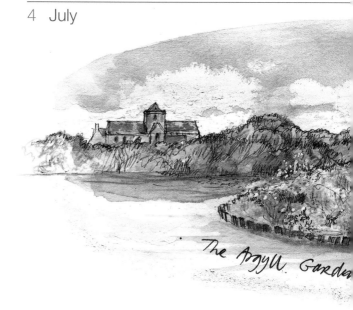

The Argyll Garden

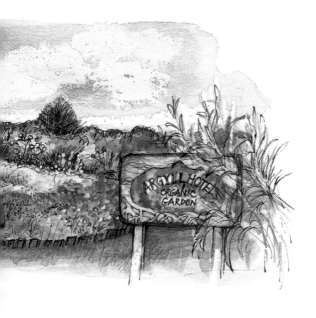

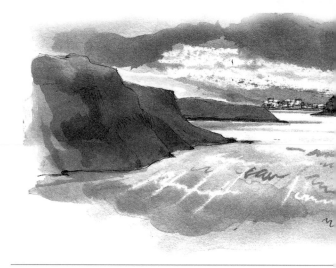

8 July

9 July

10 July

11 July

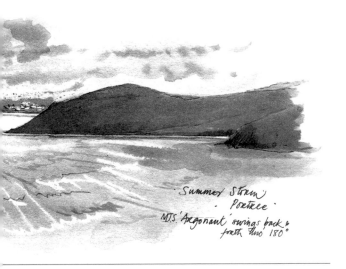

Summer Storm
Portree
M.T.S. 'Argonaut' swings back &
forth thro' 180°

2 July

3 July

4 July

15 July

16 July

17 July

18 July

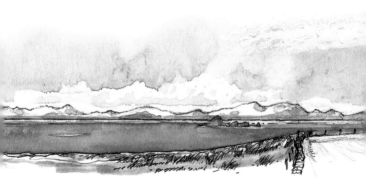

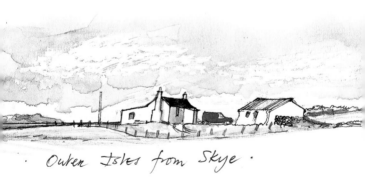

. Outer Isles from Skye .

22 July

23 July

24 July

25 July

26 July

27 July

28 July

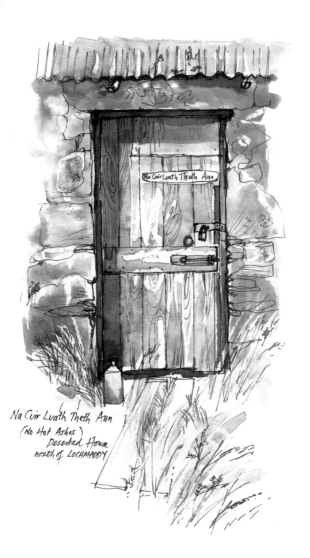

Na Cuir Luath Theth Ann
(No Hot Ashes)
Deserted House
north of LOCHMADDY

29 July

30 July

31 July

1 August

2 August

3 August

4 August

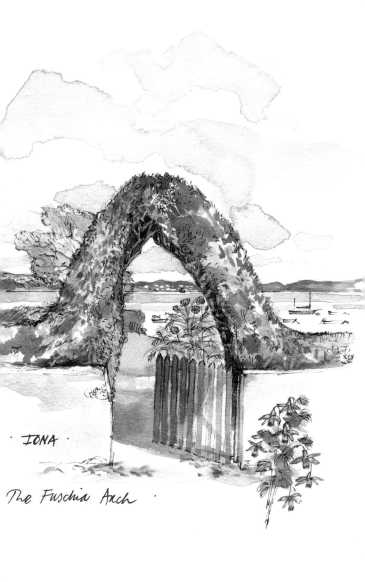

· IONA ·

The Fuschia Arch ·

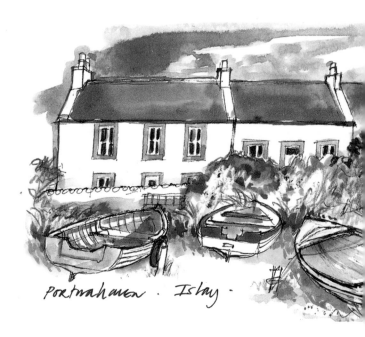

Portnahaven · Islay ·

August

August

August

0 August

1 August

12 August

13 August

14 August

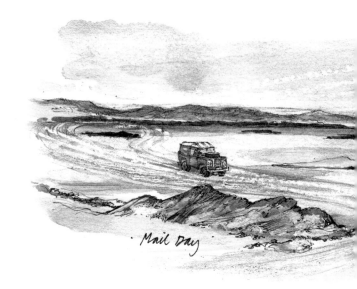

Mail Day

5 August

6 August

7 August

8 August

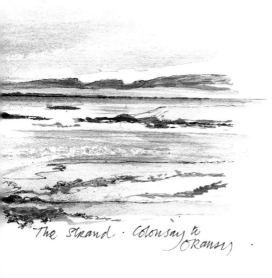

The strand · Colonsay to Oransy

19 August

20 August

21 August

22 August

23 August

24 August

25 August

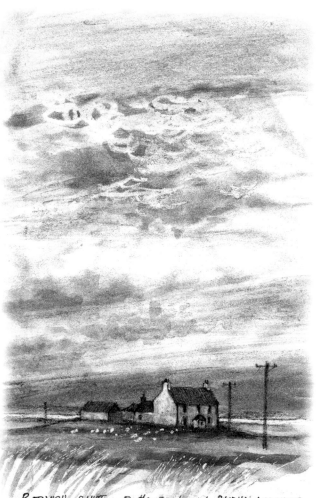

BORNISH · S.UIST · On the road out to RUDHA ARDVULE.
Mile wide machair.

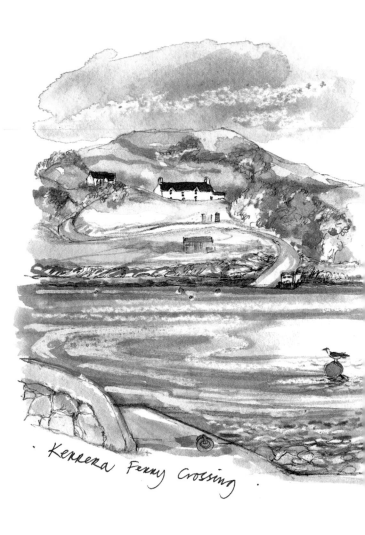

Kennera Ferry Crossing

26 August

27 August

28 August

29 August

30 August

31 August

September

2 September

3 September

4 September

5 September

6 September

7 September

8 September

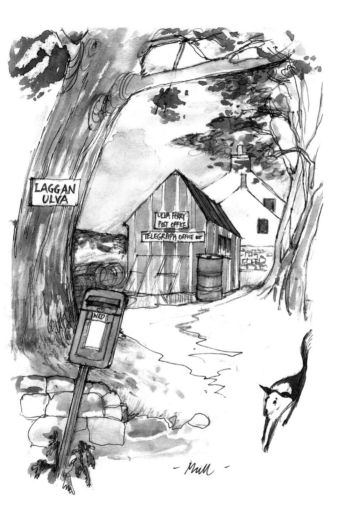

9　September

10 September

11 September

12 September

13 September

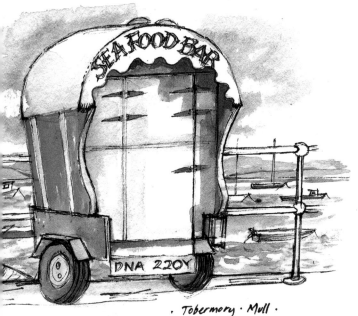

. Tobermory . Mull .

MONDAY is the best day to move house from North to South .

16 September

17 September

18 September

19 September

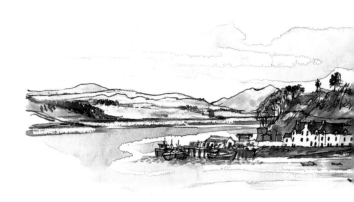

0 September

1 September

2 September

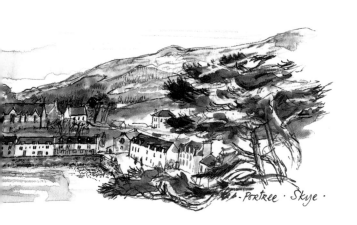

Portree · Skye ·

23 September

24 September

25 September

26 September

27September

28 September

29 September

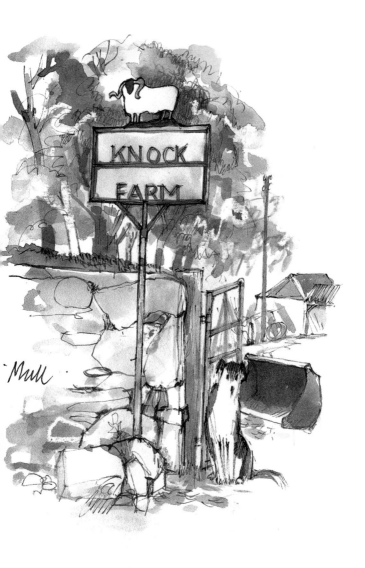

30 September

1 October

2 October

3 October

4 October

5 October

6 October

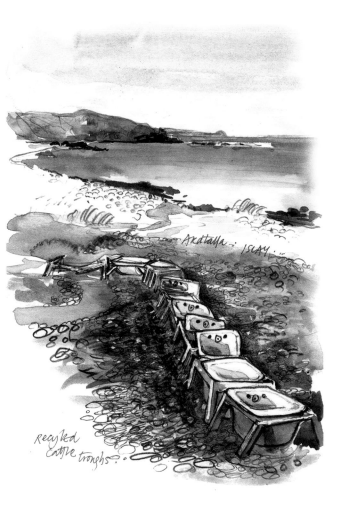

Aratalla · ISLAY ·

Recycled
cattle troughs ·

7 October

8 October

9 October

10 October

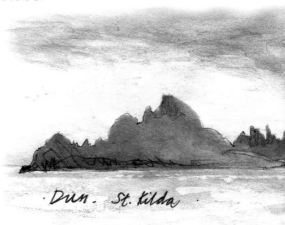

Dun . St. Kilda .

1 October

2 October

3 October

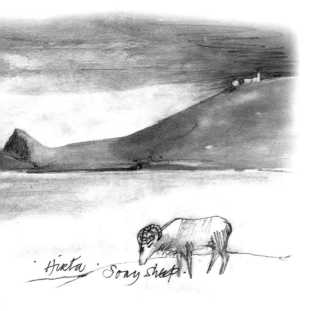

Hirta · Sony sheep.

14 October

15 October

16 October

17 October

18 October

19 October

20 October

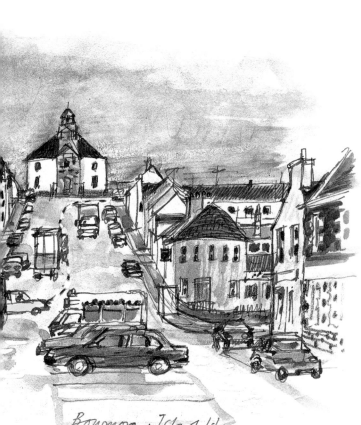

Bowmore · Isle of Islay.

21 October

22 October

23 October

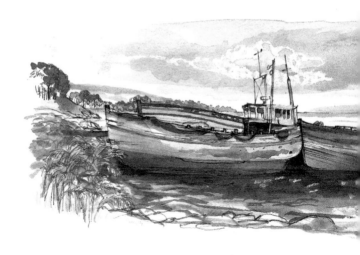

24 October

25 October

26 October

27 October

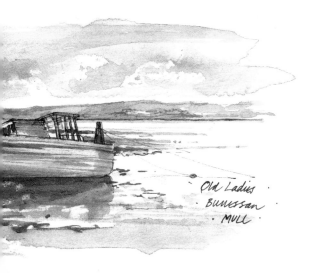

Old Ladies
Bunessan
MULL

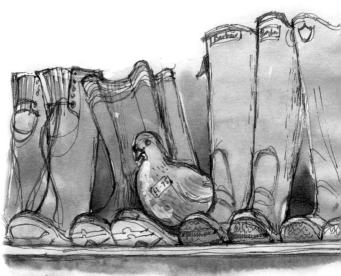

— Bridgend P.O. ~ Islay ~

30 October

31 October

November

2 November

3 November

4 November

5 November

6 November

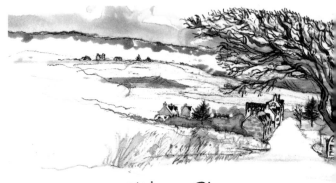

·Stein· Skye

November

November

November

November

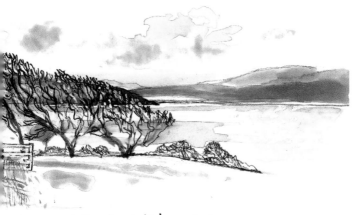

Power of the prevailing winds...

11 November

12 November

13 November

14 November

15 November

16 November

17 November

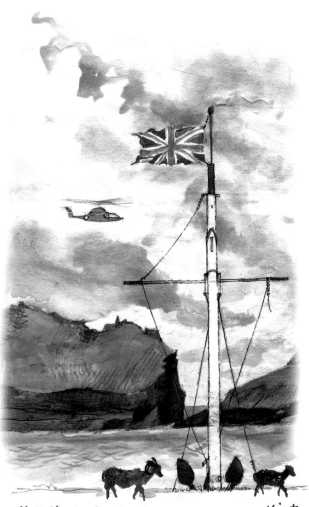

Mail Maybe Coming in Hirta

18 November

19 November

20 November

21 November

22 November

23 November

24 November

Sconser from the Top Road · RAASAY.

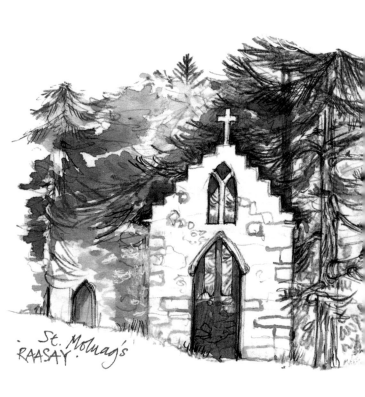

St. Moluag's
RAASAY

25 November

26 November

27 November

28 November

29 November

30 November

December

2 December

3 December

4 December

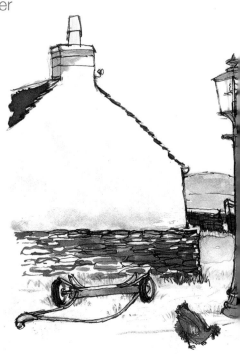

December

December

December

December

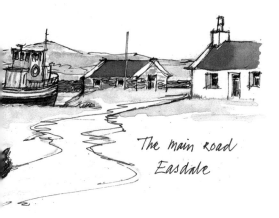

The main road
Easdale

9 December

10 December

11 December

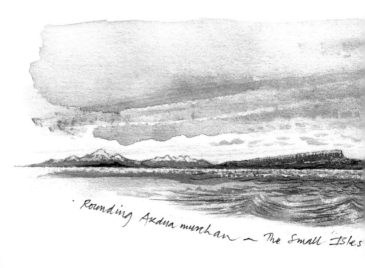

Rounding Ardnamurchan ~ The Small Isles

12 December

13 December

14 December

15 December

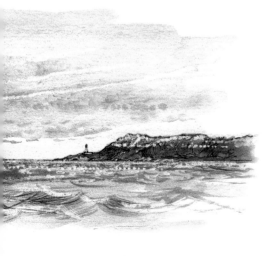

16 December

17 December

18 December

19 December

20 December

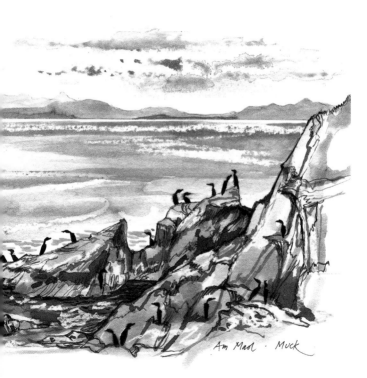

Am Maol · Muck

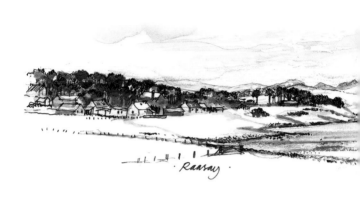

Raasay

23 December

24 December

25 December

26 December

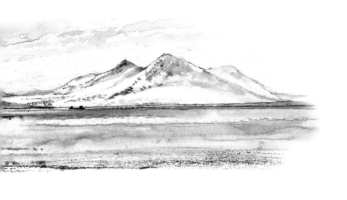

27 December

28 December

29 December

30 December

31 December

1 January

2 January

3 January

4 January

5 January

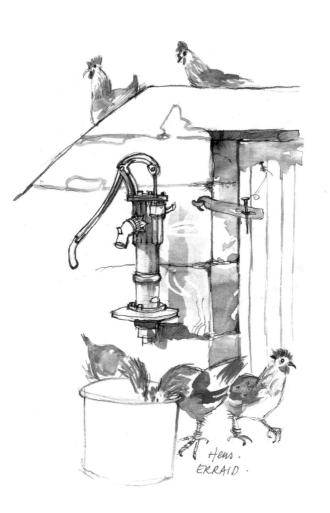

Hens.
ERRAID.

— Notes —

— Notes —

— Notes —

Notes

— Notes —

Notes

— Notes —

— Notes —

— Notes —